Calligraphy and Hand Lettering Practice Notepad

Table of Contents

Slant Angle Lined Guide Sheets 3 - 38

Alphabet Practice Sheets 39 - 74

Dot Grid Sheets 75 - 110

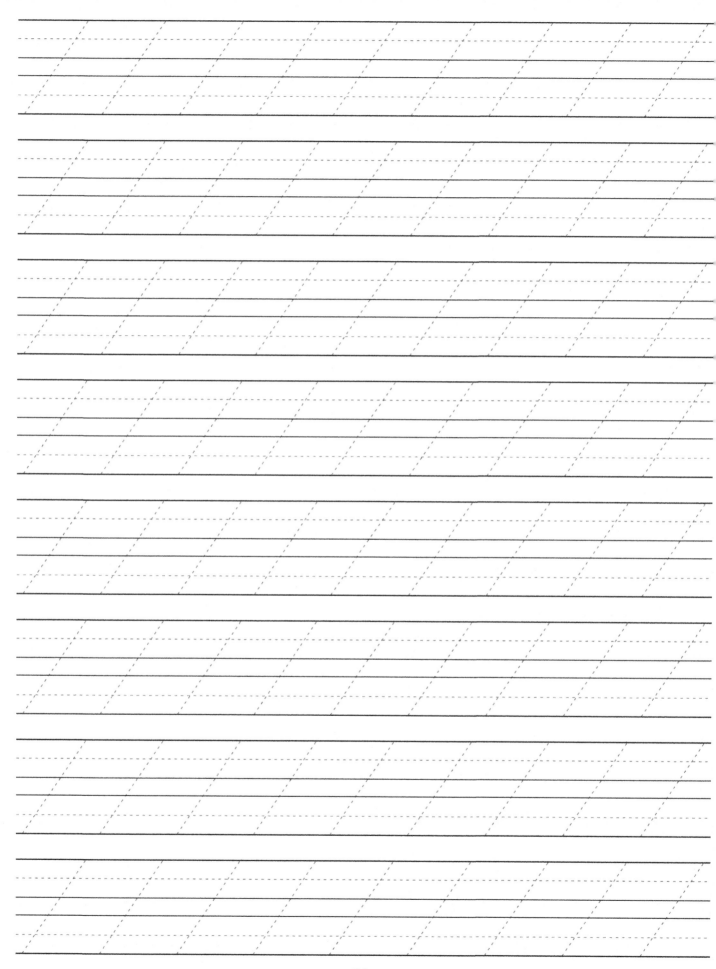

Made in the USA
Monee, IL
16 January 2021